MOODLES

··· presents ···

Happy

This edition published by Parragon Books Ltd in 2015
and distributed by

Parragon Inc.
440 Park Avenue South, 13th Floor
New York, NY 10016
www.parragon.com

Written and illustrated by Emily Portnoi
Edited by Frances Prior-Reeves

ISBN 978-1-4748-0430-1

Printed in China

MOODLES

··· presents ···

Happy

PaRragon

Bath · New York · Cologne · Melbourne · Delhi
Hong Kong · Shenzhen · Singapore · Amsterdam

Welcome
to your moodle book.

"What is a moodle?" I hear you ask. Well, a moodle is just a doodle with the power to change your mood. Be it happy to sad, sad to mad, or mad back to glad. Cheaper than therapy, quicker than chanting chakras, tastier than a cabbage leaf and sandpaper detox, and less fattening than chocolate cake!

The moodle: a simple thing that can really turn your day around.

All you need is a pen or pencil, imagination, and an open mind. Be prepared to delve into your innermost thoughts, ideas, and concepts. Uncover your subconscious and lay it bare on the page—admire it, mock it, and marvel at it until you feel altogether much chirpier. Let the moodle wisdom penetrate your subconscious and guide you on a magical mental journey; follow the line you create until the final stop—happiness!

There's nothing like a **spot of retail therapy** to lift the spirits.

Moodle your **guilt-free** purchases.

Fancy a *cool new hairdo?*

Try out a different style on each of these heads.

You're the star!

Sketch yourself in a favorite **TV** or movie scene.

Decorate your doughnuts.

Turn this scribble into your own **monster** friends.

Moodle a **flamboyance** of flamingos.

Want to be treated like a national treasure?

Draw **your face** on this stamp.

Draw yourself jumping impossibly high.

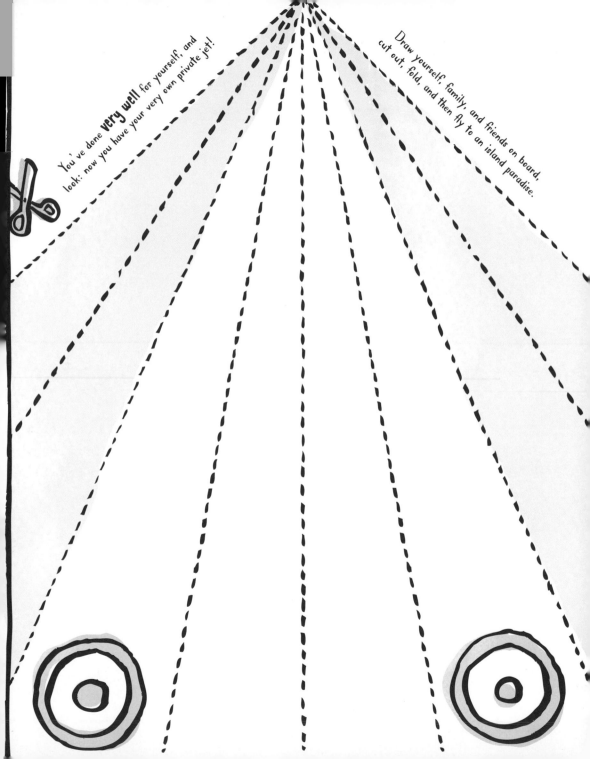

You've done **very well** for yourself, and look: now you have your very own private jet!

Draw yourself, family, and friends on board, cut out, fold, and then fly to an island paradise.

It Cara
flym ↑
hehehe
How's life xo xo

How to make your *airplane*:

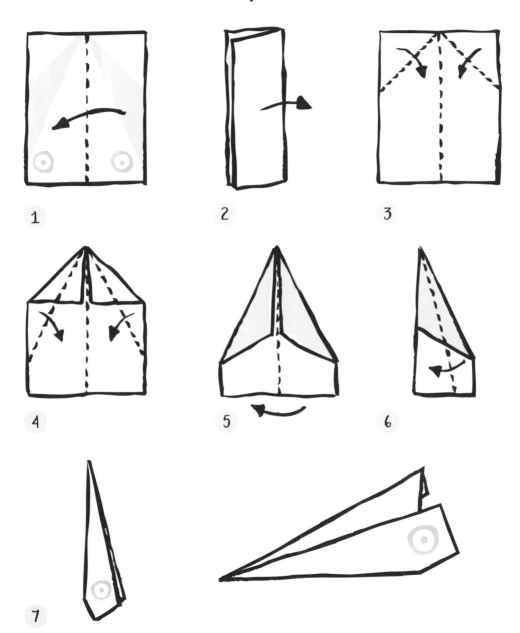

Take the largest banknote from your purse or wallet.
Hide it. Draw a treasure map.

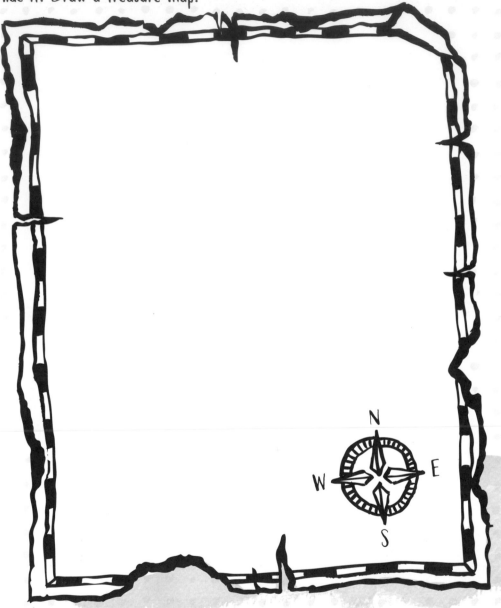

Wait 7 months, 4 days, and 3 hours. Then follow the map
to discover precious money. (YO HO HO, ME HEARTIES!)

Save all the **best** compliments you receive.

You're Magic!
What can you make appear out of the hat?

Moodle the impossible.

Sketch your *happy place,*
then escape there whenever you need to—
cheaper than a vacation package.

Stop procrastinating.

Just draw something!

(You've got 15 seconds from now.)

Finishing a puzzle can be **very satisfying.**

With this puzzle all you have to do is draw the finished picture, make it as complicated as you like, then sit back, admire, and feel smug.

Chocolate, carrot,
double chocolate,
banana, vanilla,
walnut, coffee,
triple chocolate,
with whipped cream,
cherries on top,
sprinkles ...

...you choose.

Cover the entire page in grey scribbled pencil.
Then use an eraser to draw a bright sunshine.

Get focused!

Draw your ambition here, then take aim.

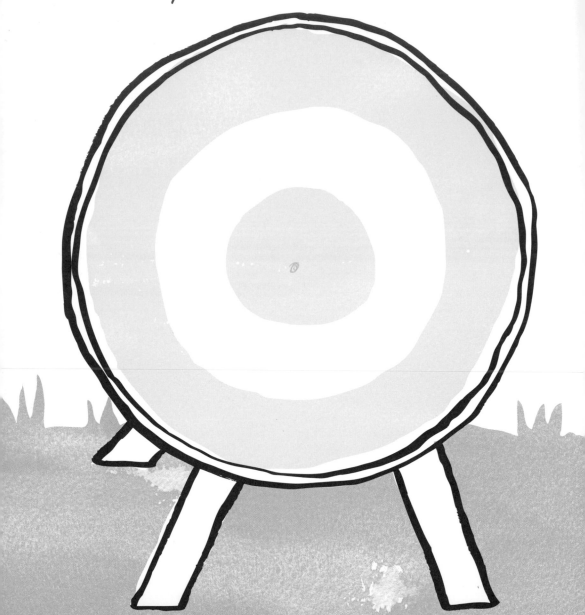

Moodle your happiest memories on this album page.

Enjoy the **little things**.

Draw five things smaller than your thumbnail.

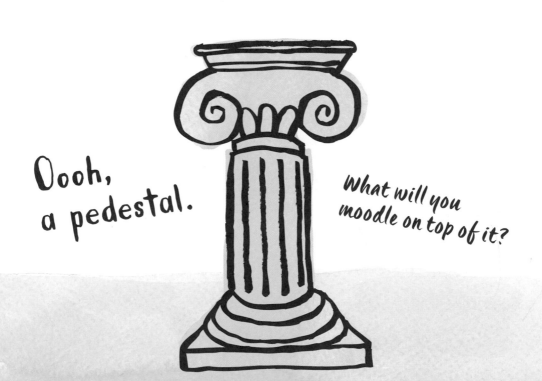

Let's go downtown and get tattoos.

Stop and smell the roses.

Draw a **massive** grin on this face.

Cut along the dotted lines and wear as a mask!

Picture the sunset...

...and relax.

Draw the **home** of your **dreams**:
the home you deserve.

Comfort food!
Moodle your favorite dish.

Mmm!

Tell the story of
your greatest adventure
in moodles.

Draw four *beautiful* things you've seen today.

Moodle the cover of your autobiography.

The key to success is
the ability to choose a path and stick to it.

Draw a picture without taking your pen off of the page.

Draw yourself dancing.

Write yourself a *love letter* with your left hand.

(Or your right if you're left handed – stop being difficult!)

Party time!

Moodle some bright, cheery decorations.

Color in this picture. Color over the lines if it makes you happier!

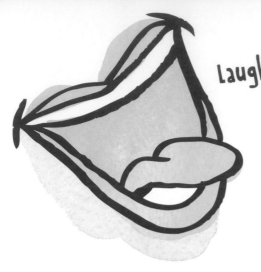

Laughter is the key to happiness.

Draw the last thing
that made you laugh.

Connect the dots in any order you
like — there is no right or wrong answer.

Keep going until you have your
own wonderful, unique design.

Quick draw.

Draw the first thing you think of when you read these words:

Gallop

Adventure

Twisted

Tag this wall.

Hooray! You've won a prize!

What's it for?

Moodle an amazing firework display.

Oooh, Aaah!

Design a **hippie's happy** T-shirt.

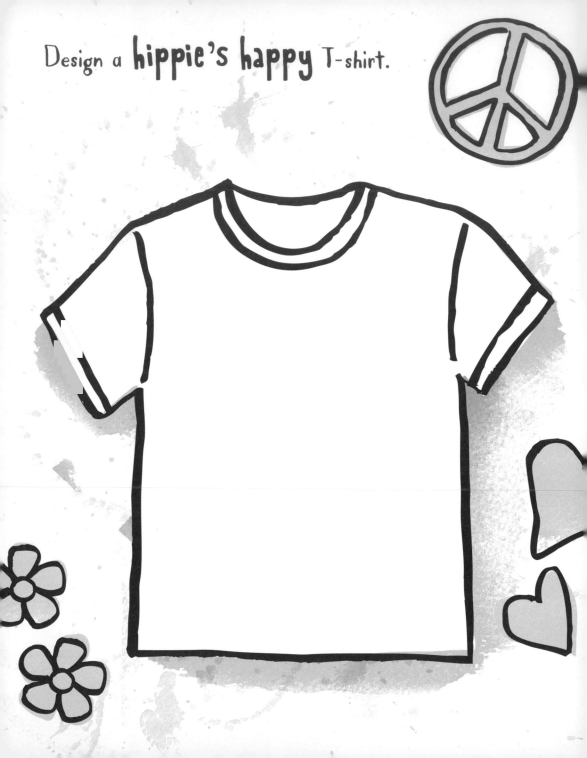

Draw a grumpy you on this page.
And a happy you on the next right-hand page.

Then flick this page back and forth.

Design your own coat of arms and DISPLAY IT WITH PRIDE.

Did it make you smile?

As the old Latin saying goes;
Carpe Diem!
Draw a fish today.

Become self-aware.

Draw what you can taste, smell, and feel.

Moodle your **greatest** achievement.

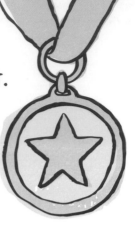

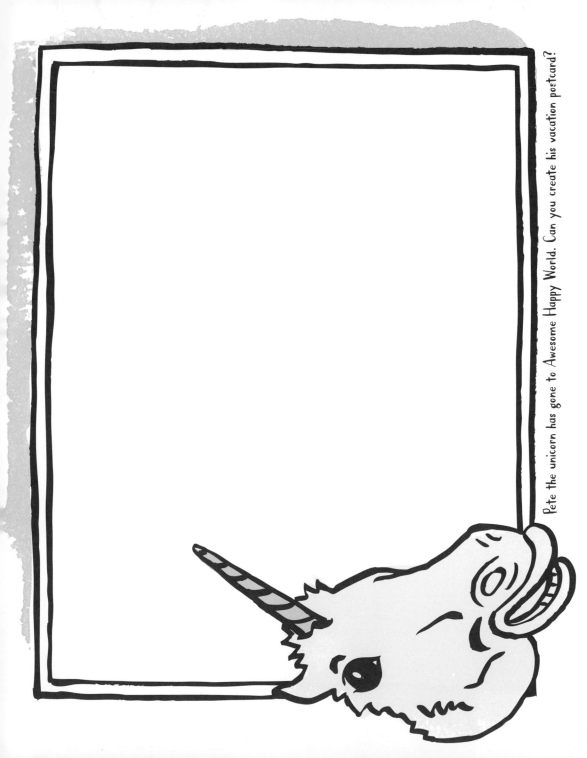

Pete the unicorn has gone to Awesome Happy World. Can you create his vacation postcard?

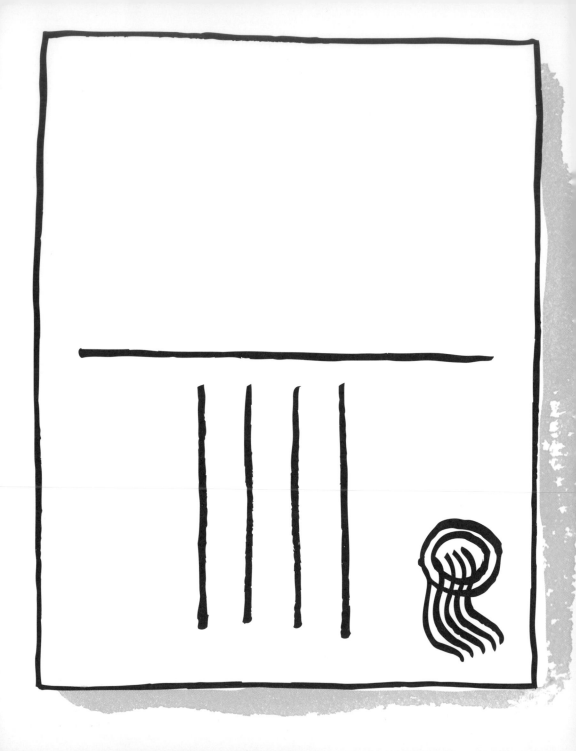

YOUR FAMILY AND FRIENDS ARE HIDDEN TREASURES.

Draw their faces on these coins
and enjoy their riches.

Moodle this penguin its soul mate.

Exercise is the *key* to happiness.

Take this book for a short, fast walk, then chart your journey on this page.

Sketch **YOUR DOOR** for opportunity to knock on.

Draw a shrine to the thing or person you love most.
(Try not to enter creepy stalker territory!)

Magnify your happiness.

Draw your smile through this magnifying glass.

Moodle yourself as an **adorable** kitten.

Moodle the song in your heart.

Since you are **truly super-duper,**
you should have a sidekick.

Moodle your **ultimate awesome** sidekick.

Reach for the stars.

Draw **THREE THINGS**
you are grateful for today.

Fill your cup with moodles.
(So it runneth over.)

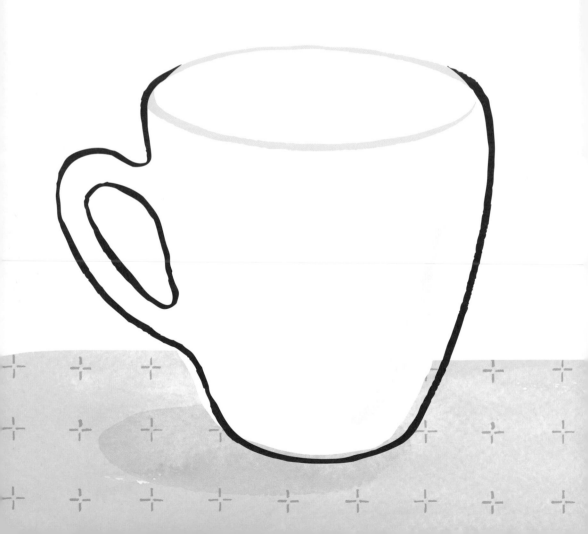

WANTED

★

MY JOY

Description:

Last seen:

DRAW SOME NEW LOGO DESIGNS
FOR **Happy Corp.**

Moodle a pyramid of snails.

Set all the clocks to Sunday morning...

...and snooze.

According to Zen philosophy, the key to inner happiness is to **consider things from every angle.** Pick an object and draw it from the top, bottom, right, and left.

A turtle's shell is his **castle.**

Give each of these turtles their own unique and wonderful shell design.

Write a coded message using only noodles. Show it to a know-it-all friend, and see if he or she can crack your code.

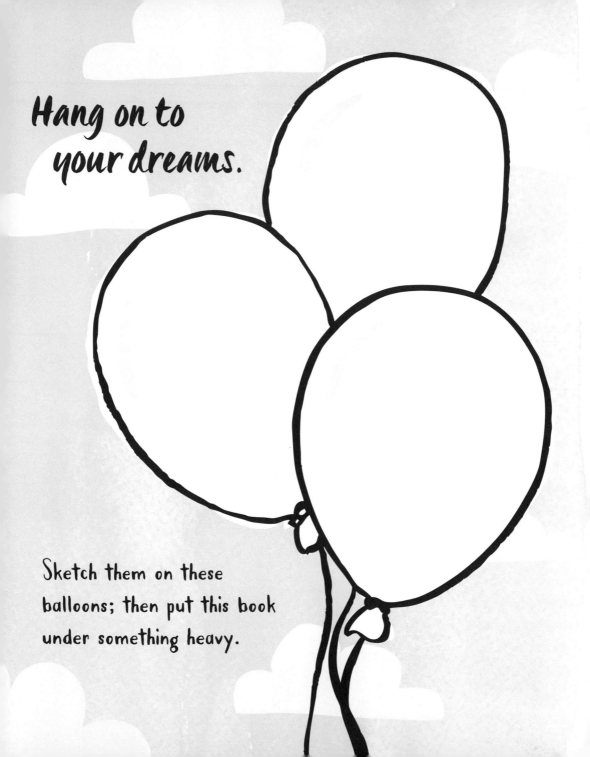

Hang on to
your dreams.

Sketch them on these
balloons; then put this book
under something heavy.

Design some fancy face topiary to make you smile.

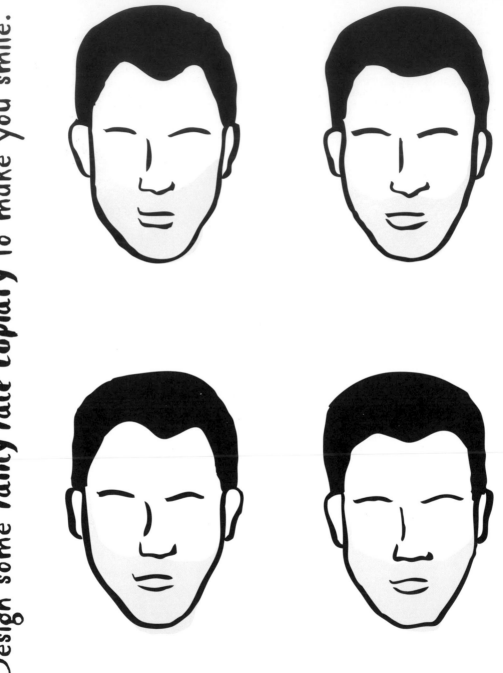

Moodle your message in a bottle.
Then let it set sail on the high
seas of *chance and fate.*

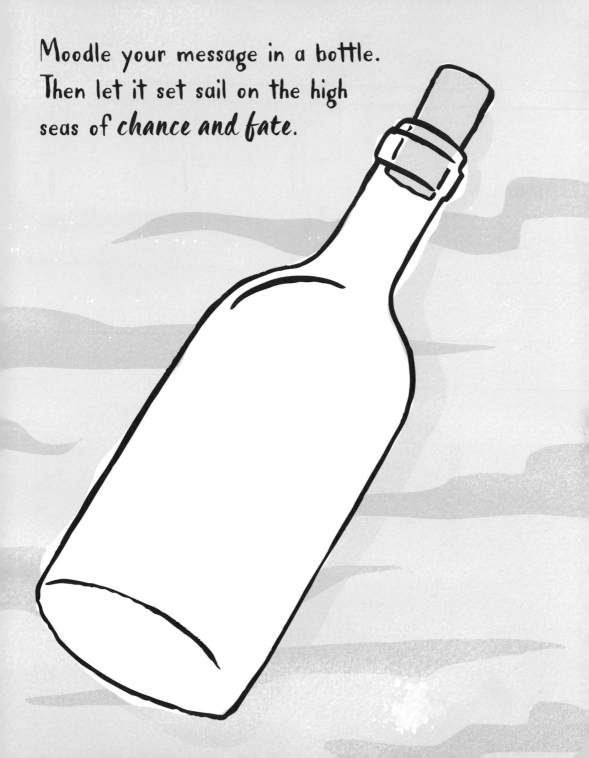

Practice your smiles.

Moodle them here.

Smirk

Grin

Beam

Pout

Coy

Excited

Happy

Surprised

Sassy

Mischievous

A wise man once said,
"Count your age by friends, not years."

Moodle all your friends as candles on your cake.

Supplement your life.

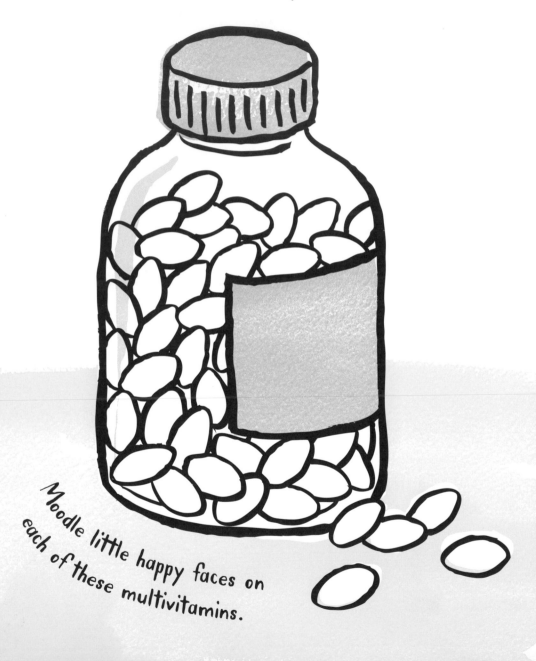

Moodle little happy faces on each of these multivitamins.

Moodle your name **really** enthusiastically.

These are your *love letters.*
Decorate them with hearts and flowers.

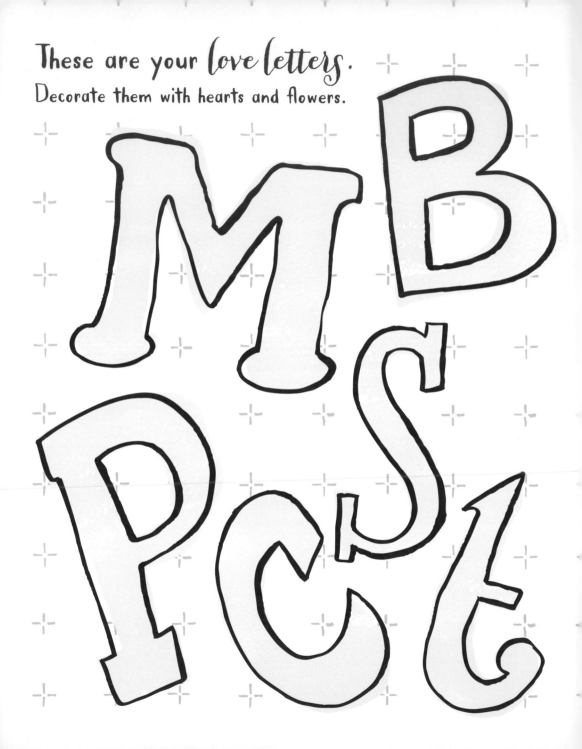

Draw around your toes and then moodle them into a family of piggies.

Moodle the faces these **funny noses** belong to.

Get the *most* out of life.

Moodle on this page until there isn't a speck of white showing.

Moodle yourself as a superstar.

Hide 20 miniature grinning
frogs on other pages of this book.

TRAVEL BROADENS THE MIND.
Moodle ...

...on the toilet.

- -

...at the foot of your bed.

...at the top of the stairs.

-- -- - -- -- -- -- -- -- -- -- -- -- -- -- -- -- -- -- --

...on your doorstep.

Nothing beats a homemade meal to warm your soul.
What are YOU cooking?

cheer up this old deer.

Moodle in the rest of her body.

Moodle your favorite view,

so that you can take some time to enjoy the view whenever you have a spare minute.

You're a super human!

How much can you balance
on your pinkie?

Surprise! Here's a little present for you. Moodle your own surprise gift. Then act surprised.

Start an appreciation society for...

Moodle the sun coming out.

Moodle a rainbow.

Moodle
a pot of gold.

This poor polar bear has **chilly toes.**
Moodle him some woolly socks.

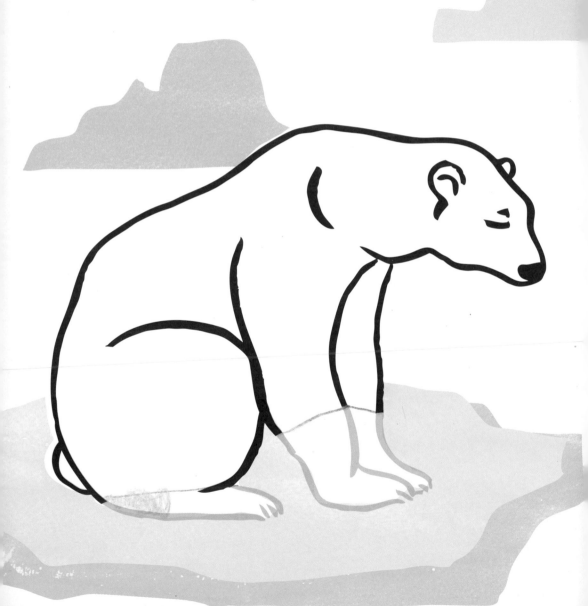

And the winner is...

Write your winner's acceptance speech.

- salt
- orange 2 for $3.00
- spuds
- veg
- garlic
- butter
- cream spray
- lemon juce
- thick bleach
- soup
- condensed milk

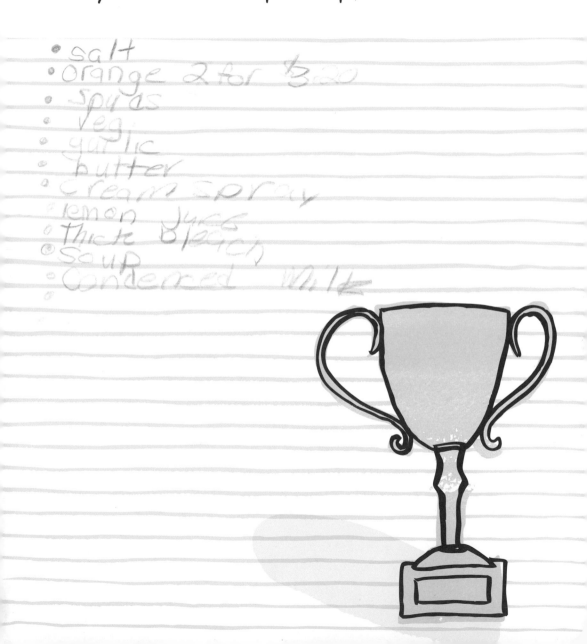

All moodles complete and wisdom absorbed, you will by now have reached a state of complete and utter happiness. You may well be floating on a higher mental plane, radiating love, Zen, and light. And if you ever come down again, simply revisit the pages of this book to top up your happiness.